The City and the Country:
American Perspectives
1870-1920

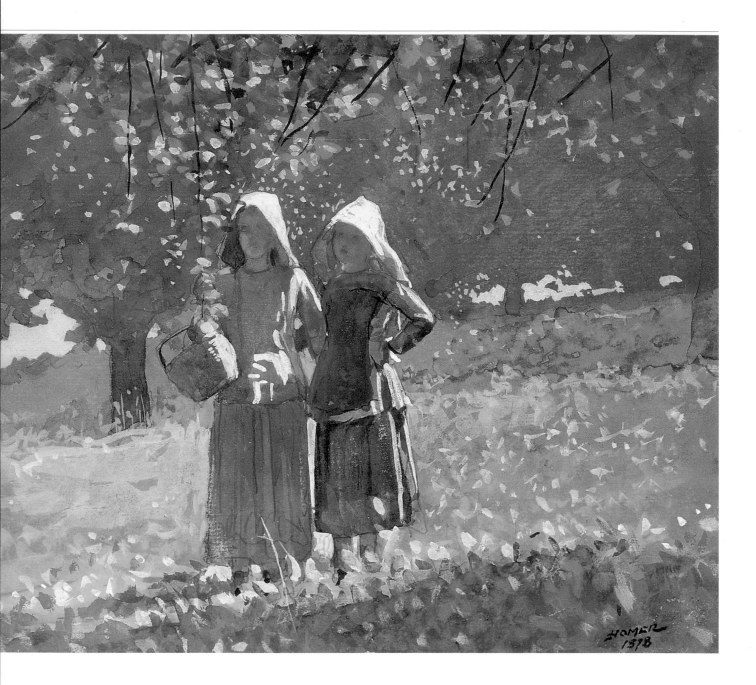

The City and the Country:
American Perspectives
1870-1920

1 April - 31 October 1999
MUSÉE D'ART AMÉRICAIN
GIVERNY

10 December 1999 - 7 May 2000
TERRA MUSEUM OF AMERICAN ART
CHICAGO

Published by Terra Foundation for the Arts
On the occasion of the exhibition
The City and the Country: American Perspectives, 1870-1920
at Musée d'Art Américain Giverny
1 April to 31 October 1999
shown in variation at
Terra Museum of American Art
10 December 1999 to 7 May 2000

Preface © Margaretta M. Lovell

ISBN 0-932171-09-5

Design by François Coulibeuf
Printed in France by G.P.A.

Cover:
Charles Courtney Curran,
In the Luxembourg Garden, 1889

Frontispiece:
Winslow Homer,
Apple Picking (Two Girls in Sunbonnets), 1878

CONTENTS

Acknowledgements

Any exhibition that takes place at the Musée d'Art Américain Giverny owes thanks in the first place to the late Ambassador Daniel J. Terra and his wife, Judith Terra. Their commitment to understanding, appreciating, and telling the intriguing story of American artists in France has found expression in all of the museum's activities since its opening, in 1992. It is hoped, too, that their unique, visionary spirit informs both this catalogue and the major exhibition that occasions it, *The City and the Country: American Perspectives, 1870-1920*. The Board of Directors of the Terra Foundation for the Arts has made this project possible. I greatly appreciate their encouragement and unhesitating support.

Several scholars have been generous with both their time and ideas during the planning stages of this exhibition. Early on, Theodore E. Stebbins, Jr., John Moors Cabot Curator of American Painting at the Museum of Fine Arts, Boston, discussed the concept with me and offered helpful advice. Carole Shelby's research on the permanent collection of the Terra Foundation for the Arts has proved an indispensable resource. Marc Simpson, my primary teacher in things curatorial, provided guidance. Veerle Thielemans shared her sophisticated approach to problems of landscape and memory. Finally, I would like to thank Margaretta M. Lovell, Associate Professor in The Department of the History of Art at the University of California, Berkeley, for contributing an insightful preface to this catalogue.

I am deeply indebted to the staff of the Terra Museum of American Art, Chicago for all of their hard work on *The City and The Country*. John Hallmark Neff, TMAA's Director and Chief Curator, took an interest in the project from its inception. I also would like to express my gratitude to Mary Ellen Goeke, Tom Skwerski, Stephanie Mayer, Shelly Roman, Amy Henderson, and Kristina Anderson for their unfailingly superior assistance with various details of the exhibition. Kristin H. Lister and Harriet Stratis, also in Chicago, shared their expertise with regard to object conservation matters. One could not imagine better long-distance colleagues than these.

Last of all, but definitely not least of all, I wish to acknowledge the staff of the Musée d'Art Américain Giverny. They immediately supported me in the role of curator of *The City and the Country*, just as they warmly welcomed me into my new place as Director of the museum. I would like especially to thank Véréna Herrgott and Maureen Lefèvre, both of whom have gone beyond the call of normal duty to make this endeavor successful. I would also like to thank Marie Bosson, Didier Brunner, Didier Dauvel, Diana Guillaume, Jacqueline Maimbourg, Véronique Roca, and Olivier Touren. François Coulibeuf is responsible for this catalogue's elegant design, and Alan Waite produced the French translation. They all have my admiration and respect.

Derrick R. Cartwright
Director
Musée d'Art Américain Giverny

Preface

Margaretta M. Lovell
University of California, Berkeley

This exhibition, highlighting the extraordinarily rich group of Terra collection paintings of the late nineteenth- and early twentieth-century period, presents these works in two compelling thematic clusters: landscapes and cityscapes. In conjuring "landscape" as the key concept, this exhibition gestures in two important directions — toward the general historic artistic tradition in which these works participate on the one hand, and toward the specific thematic concerns addressed in the images on the other, toward the long past of art, in other words, and toward the vibrant present of American (and European) *fin-de-siècle* culture.

Focusing on genre enables us to see the many gifted artists represented here looking at, recording, and interpreting the countryside and the cities they and their contemporaries strolled through, admired, and sought to preserve in the special language of art. A genre perspective also helps us to investigate and consider the nature of landscape painting with its signature horizontal format, its language of bracketing repoussoir features, and its long history stretching back through the English masters Thomas Gainsborough and John Constable, to the Dutch seventeenth-century immortals, and the Franco-Italianate innovators Claude Lorrain and Nicolas Poussin. The American artists whose works are celebrated here were aware of this important tradition of seeing, documenting, and framing features of the natural and built environment. But by the late nineteenth century, their acknowledgement and visual quotation of predecessors was not even necessarily a conscious behavior; it would have seemed natural. And indeed it might be. It is quite possible that certain ways of seeing space are privileged over others because humans are 'hard-wired' to seek out the prospect, the elevated view encompassing clearly distinct, and clearly linked near, middle, and distant features, for instance, finding it psychologically satisfying in ways now disengaged from primal desires for safety derived from visual knowledge.

By the late nineteenth century both artists and their audiences would have understood the conventions of landscape depiction and would have recognized and enjoyed recognizing deliberate disruptions of these expectations in the sub-genre of cityscape. For while the painters of the countryside tended to reinforce established modes of seeing trees, structures, and fauna, focusing on ancient buildings, outdated technology, and premodern social hierarchies, the painters of the city enjoyed torquing the same visual conventions to disrupt the expectations set up by the tradition, insisting instead on vertical formats, abrupt spatial

transitions, and ambiguous human ecologies. Seen together, late nineteenth- and early twentieth-century landscapes and cityscapes give us two sides of the same coin, two alternative views of art and of culture—one tending toward cultural retrospection, history, and the traditions of art, and the other (while deliberately playing on and referencing the former), embracing the modern.

These views give us, in distilled form, a window on a world half-perceived and half-constructed, a world which the artists have made into legible, coherent vignettes for our pleasure and curiosity a century later. Looking back 'through' these works, we can use art as a cultural lens to see not only what *was*—what facts and details of costume, park design, hay ricks, and café chairs were there to be observed—but also to see *how* those facts were arranged poetically, emphatically, and memorably to capture the attention and imagination of potential patrons then and of art lovers today. Above all, they cue us to those aspects of daily experience and of special or vacation experience that were deeply valued in that not-so-distant past.

Drawing attention to landscape and cityscape as special kinds of (historical) artmaking and special kinds of (*fin-de-siècle*) cultural geography, this exhibition asks us to attend to the points of intersection between these two meanings of "landscape." Engaging art thematically and culturally in a serious manner is a relatively new enterprise. Until recently, many exhibitions of American art focused on the oeuvre of a single master or on the accomplishments of a 'school' as in the notably beautiful but not uncontroversial exhibition *American Light: The Luminist Movement, 1850-1875* (National Gallery of Art, Washington, 1980). Such scholarship emphasized the biographical, analyzed the formal qualities of paintings, and attended primarily to questions of aesthetic 'influence.' A little over a decade ago we began to see exhibitions and important scholarly projects—such as *The Catskills: Painters, Writers, and Tourists in the Mountains, 1820-1895* (The Hudson River Museum of Westchester, New York, 1987), and *Reckoning with Winslow Homer: His Late Paintings and Their Influence* (The Cleveland Museum of Art, 1990)—which positioned art objects primarily within a framework of spatial and cultural history and used them to help understand and explicate that history. How, Kenneth Myers, the author of *The Catskills* exhibition and catalogue asks, did the paintings of those dramatic and accessible mountains recapitulate and build on the expectations of ordinary tourists (and would-be tourists) who made excursions to mountainside hotels and cascade-side

1. Dennis Miller Bunker,
Brittany Town Morning, Larmor, 1884

sites to observe specific prospects and effects? Taking a slightly more complex problem, *Reckoning with Winslow Homer* focused on a single site—the Maine coast—first investigating the uses to which Homer put it in his search for a subjectless subject, and then on the works of those who wrestled with the same abstract-concrete problem of rock and wave in the long shadow of that master.

Other scholars have looked at the extraordinary blossoming of landscape painting in nineteenth-century America within the context of politics, ideology, and science. But however coded within structures of power and knowledge, the paintings also always point to travel, tourism, recreation, and visual curiosity concerning the quotidian—just those aspects of life captured and held up to view in this set of works. It appears that painters seized on models of sight and vocabularies of vistas, objects, and characters that their contemporaries sought out in their leisure moments for visual inspection, admiration, or curiosity.

An exhibition such as this enables us to see not only an impressive slice of the history of landscape painting, and its sub-category cityscape, but also asks us to inquire closely into the meaning of landscape as a genre at a given cultural moment within a specific cultural milieu. It seems clear that these paintings summarized and reinforced important cultural concepts (and mythologies) concerning nature, urbanism, and appropriate human relations in each sphere. Dennis Miller Bunker, for instance, rivets our gaze on the verdant fields embracing an ancient Brittany village (fig. 1), and Maurice Prendergast transports us to Paris's well-ordered Luxembourg Garden with its watchful nannies and salubrious shade (fig. 2). Bunker uses the traditional horizontal landscape format, a stable horizon line providing a comfortable expanse of sky, and a gentle series of diagonals to draw us into and through his composition—the image uses traditional language to describe an historical scene, bounded by cyclical and historical practices of village and rural life. This is a view consistent with contemporary concepts of nature as healthful, therapeutic, nurturing an integration of human with natural processes and valorizing ancient usages. Prendergast, on the other hand, confounds the expectations of landscape by tipping the frame up vertically, crowding the foreground and the center of his image with too-close, overlapping features recessing abruptly to an unusually high horizon line. In its nervous disruptive manner and its focus on urban amenities both seen (public parks) and implied (transportation systems, policing infrastructures), the Prendergast cityscape declares its modernity.

In their various strategies for presenting landscape facts and in their individual acts of inclusion, exclusion, selection, and deletion, this corpus of works instructs us in the ways the dynamic urban sphere and the productive countryside were seen, understood, and valued by the artists' contemporaries as well as by the artists who sought their attention and patronage. And we also can infer, from looking at these images as a set, those zones and activities from which the artistic gaze was resolutely averted. Repeatedly here the city is presented as a site of recreation in which public parks, cafés, bridges, street lighting, omnibuses, theaters suggest leisure and pleasure within an amplitude of urban amenities and variety . The countryside, on the other hand, is presented as a zone of labor, but the forms of labor we are shown are archaic — hay rakes, wheelbarrows, small flocks of sheep, and individual workers instead of the McCormick reapers that revolutionized agricultural businesses and integrated the farm into the economy and practices of urban life by 1900. In neither case is there direct reference to the deforestation, mining, quarrying, assembly lines, or company towns, that formed the backbone of the booming late nineteenth- and early twentieth-century economy on which the market in paintings depended.

Curiously, as this exhibition makes quite clear, Europe was as much the site of American painting and mythologizing as was the United States during this period, perhaps even more so. Although there are some continental differences (the skyscrapers signaled new world urbanism while the café concert evoked Europe) the basic aesthetic dichotomy between landscape and cityscape, between the creativity, excitement, anonymity, and ambiguity of the city on the one hand and the pastoral, georgic countryside on the other, was international and not specific to either continent. In both venues the artist as 'anthropologist' of the present, drew on his or her memories of the history of landscape-making in order to evoke the older values of the one kind of space or to conjure up the vitality and novelty of the other. Genre, subject, tradition, and treatment all intersect in the artists' creation of, and our reading of, each of these extraordinary images of an extraordinary artistic and cultural moment. By gathering them together, this exhibition contributes to the ongoing project of seeing the rich flowering of turn-of-the-century American painting in ever sharper cultural focus. ∎

2. **Maurice Brazil Prendergast**,
The Luxembourg Garden, Paris, 1892-94

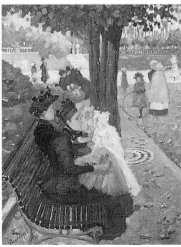

Between Hard Places and Rocks: The City and the Country in American Art

Derrick R. Cartwright

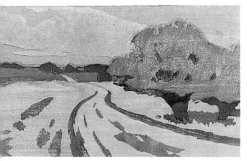

1. **Edward Willis Redfield**,
France, 1898-99

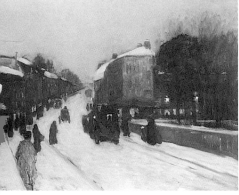

2. **Arthur Wesley Dow**,
The Purple Sky (The Long Road), Spring, 1916

"What to depict and how to depict it?": these are essentially historical questions and they circulate around almost any creative inquiry we might imagine. American artists' fascination with a wide variety of subjects can be easily demonstrated. Painters who worked along the Atlantic seaboard between the mid-seventeenth and mid-nineteenth centuries, for example, excelled at portraiture, still life, history painting, scientific illustration, moralizing landscapes, and scenes of everyday life, to name just a few preferred genres. Toward the end of the last century, views of the city and the country competed with these other privileged themes for broad public attention in the United States. The basic approach that these artists brought to problems of representing urban and rural scenes changed during this period as well. Informed to a large extent by their direct experience of European cultural centers, most importantly Paris, the generation of American painters and sculptors who came to maturity in the decades after the Civil War produced a strikingly new kind of image (figs. 1 & 2). Different in mood and technique from earlier landscapes, these artists' turn-of-the-century depictions of the city and the country provide us with opportunities to reflect upon fundamentally unique issues in American art history.

The landscape itself evolved in complex ways between 1870 and 1920. Social life throughout Europe and the United States shifted irreversibly from its traditional agrarian base to more modern, and dense, urban contexts during these same years.[1] The population of Paris more than doubled between 1850 and 1880, and New York experienced even more explosive growth. Consequently, small towns and villages were becoming less significant, both in terms of their size and their political presence. Recognizing these facts takes us only part of the way toward making sense of the landscape imagery from this time, however. These root demographic changes coincided with equally basic changes in the practice of making images.

Enrollment in Europe's art academies flourished across these very same years and a sizable percentage of these new pupils were American.[2] While some of these students took advantage of regimented life drawing classes and opportunities to copy masterpieces in major museums, others simply could not be kept indoors. The attractions of modern Paris—its cafés, restaurants and other amusements—were too compelling (fig. 3). American artists were quick to grasp the advantages of working out of doors. The practice of painting *en plein air*, while not new in France, also came into its own at this time. In turn, the movement of

artists beyond city limits put them in more direct contact with rural types who became favorite subjects. The search for novel imagery in the late-nineteenth century extended to non-Western pictorial sources, perhaps most evident in the rage for Japanese woodblock prints, or *ukiyo-e*, as well as in the proliferation of new media, such as photography. Taken together, study of these sources may have further heightened these individuals' sensitivity to perceptual concerns. The world was being perceived differently by these men and women. Accordingly, their approach to the landscape was revised in these decades.

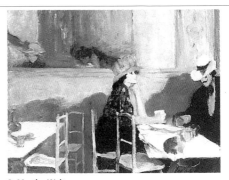

3. **Martha Walter**,
A la crémerie, 1910

Art students commonly spent months, even years abroad. Some of them, such as Mary Cassatt and James Abbott McNeill Whistler (fig. 4) stayed in Europe long after their student years, as admired expatriates. Others, such as Robert Henri and Elizabeth Nourse, traveled back and forth between the two continents many times. In search of new experiences, new horizons, in effect, new "landscapes," these artists found them in abundance in France. It was possible for these men and women to achieve unprecedented artistic success, even according to French terms, at this time.3

The conditions of this prolonged exposure should not be underestimated. European pictorial and literary arts underwent their own radical transformations throughout this period. The works of the Barbizon painters, vanguard Realists, academic artists, Impressionists, and post-Impressionists all proved highly influential for these young, foreign observers. Most of these men and women resettled permanently in the United States, however, and turn-of-the-century art was invigorated by their experience. *The City and the Country: American Perspectives, 1870-1920* tells the story of this important new vision.

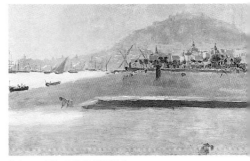

4. **James Abbott McNeill Whistler**,
The Beach at Marseille, c. 1901

There are good reasons for mounting an exhibition of American art around themes of urban and rural spaces. An impressive body of scholarship addressing these subjects has appeared in recent years and an exhibition provides an ideal occasion to think through these new interpretations in the museum context.4 Second, and still more crucially in this case, the Daniel J. Terra Collection and the Terra Foundation for the Arts possess tremendous depth when it comes to paintings, sculpture, and graphic arts related to American and French contexts. This exhibition gathers together more than one hundred works from these permanent collections. It makes sense, therefore, to take advantage of these special resources and to try to make meaningful connections between both these themes and nations.

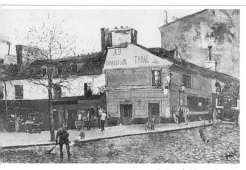

5. **Frank Myers Boggs**,
Street Scene in Paris, 1878

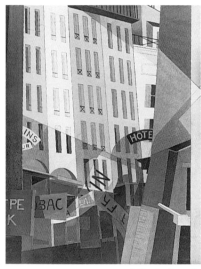

6. **Charles Demuth**,
Rue du singe qui pêche, 1921

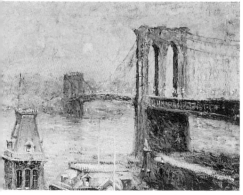

7. **Ernest Lawson**,
Brooklyn Bridge, 1917-20

As a project that seeks to both identify and reconsider certain assumptions about art making in this period, *The City and the Country* presents numerous avenues for exploration. The distinctions between (more or less) traditional and (more or less) modern approaches to painting suggest one obvious point of departure. For example, the city painted by Frank Myers Boggs (fig. 5) looks strikingly unlike the city depicted by Charles Demuth (fig. 6). Boggs, who was Ohio-born but spent the majority of his adult life in France, provides us with a view of an older neighborhood. As spectators we are granted unobstructed perspectival access to the scene. The subject that lies just beyond the foreground elements is telling. The choice of this particular kind of Parisian street must be reckoned in terms of its visible difference from that city's sparkling boulevards, themselves a recent phenomenon brought about by Baron Georges Eugène Haussmann's ambitious policies for rebuilding Paris. Boggs created a deliberately nostalgic image, yet one that also remains foreign. The picture functions as a kind of post-memory—an experience of an enduring "old world" that was imaginatively un-available to many Americans except in the form of such representations.[5] This was, of course, but one way to represent a city street.

For Demuth, who forty years later painted from memory an ostensibly French view, the salient features of the city appear in sharp contrast to Boggs's presumptions of coherent notation and detailed, if faintly touristic, observation. Demuth interpreted the European city strictly in terms of its multiple facets. In place of carefully plotted bodies and purposefully legible signs of commerce, the architecture of *Rue du singe qui pêche* fills the canvas from top to bottom, while fragments of words tumble across its picture plane. Art historians have described Demuth's vision as an "accidental" approach to abstraction, informed perhaps by a Dadaist's appreciation for chance effects.[6] If so, his jagged compositions beg us to consider such places as sites for fortunate accidents. Indeed, the twentieth-century city was understood by many as a site for exhilarating, unexpected experiences and thus presented a strong contrast to those reassuring, nostalgic views favored by some of the earlier artists in this exhibition. Demuth effectively communicated modern sensations of immense scale, intense speed, and uncontrolled perceptions in his rendering of a European city.

Cities in the United States were, of course, in similar states of flux. Critics such as Paul Bourget and Henry James were both bemused with and transfixed by their turn-of-the-century urban milieus.[7] Furthermore, and unlike Europe, few

prior models and no clear consensus existed for viewing the American city on its own unique terms. One needs only to compare two representations of the same iconic subject matter, the Brooklyn Bridge, to find evidence of the ways in which city spaces might be seen differently by artists who worked at the same time and in the same place (figs. 7 & 8).

8. **John Marin**,
Brooklyn Bridge, on the Bridge, 1930

Urban planners tirelessly rethought and reconstructed the American city at the end of the nineteenth century. European models provided at least one attractive model for this task. Charles Courtney Curran's view of dappled light and recognizably urban types in the Luxembourg Gardens (see cover) was repeated in many park scenes of this time. In this exhibition alone we might compare the image by Curran with important North American representations of landscaped gardens by Maurice Prendergast, Edward Simmons, and George Luks. Similarly, the success of world's fairs like the 1889 Exposition Universelle in Paris found their counterparts in vibrant American spectacles, like Chicago's World's Columbian Exposition (1893) or the Panama Pacific International Exposition in San Francisco (1915).[8] The City Beautiful movement, with its predilection for resplendent civic plazas, landscaped parks, broad boulevards, and other clearly-ordered spaces was well represented by artists of this time. Childe Hassam, once called America's "street painter, *par excellence*," is a case in point.[9] The flickering impressionist brushwork seen in his view of Boston's Commonwealth Avenue (fig. 9) captures both the sense of shimmering transformation and ebullient optimism conjured by contemporary civic-minded discourse.

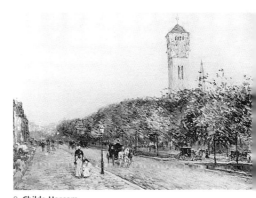

9. **Childe Hassam**,
Commonwealth Avenue, Boston, c. 1892

Public art works played a practical role in that emergent discourse as well. American muralists and sculptors, such as Frederick MacMonnies, translated their appreciation for monumental European works into the American idiom. Sometimes these efforts were well appreciated by their American audiences. Other times, they were met with consternation and befuddlement. When the architect Charles Follen McKim tried to present the Boston Public Library with a cast of MacMonnies's *Bacchante and Infant Faun* (fig.10), a public uproar ensued. Too "immodest" for many genteel Bostonians who found the reveling nudes unsuitable for public display, the city's art commission ultimately refused the gift.[10] Such controversies demonstrate the historical nature of popular taste and public art debates. They also illuminate the ways in which civic space can be understood as a screen against which the ambitions and fantasies of both artistic visionaries and broad public were routinely projected. Some turn-of-the-century

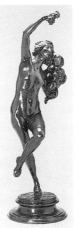

10. **Frederick MacMonnies**,
Bacchante and Infant Faun, 1894

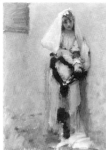

11. **John Singer Sargent,**
A Parisian Beggar Girl, c. 1880

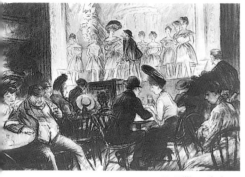

12. **William Glackens,**
A Headache in Every Glass, 1903-04

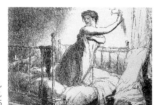

13. **John Sloan,**
Turning out the Light,
1905

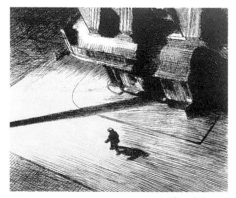

14. **Edward Hopper,**
Night Shadows, 1921

ambitions were triumphantly realized—America's famed city parks are eloquent testimony to this fact—while other dreams were simply unrealizable at the time.

Any study of urban imagery from this period must also contemplate the contradictions of urban environments. The aggrandizement of modern life's pleasures finds its counterpart in artists' somber meditations upon urban miseries. French artists first laid claim to this material in their summary, confrontational works from the 1860s and 1870s. Looking at the depictions of urban nightlife created by Everett Shinn and Richard Emil Miller in this exhibition, it is hard not to think of Edouard Manet or Edgar Degas as important precedents. American artists tended to be more equivocal than their French precursors when they rendered the urban demi-monde, however. Perhaps they were simply unfamiliar with the codes of that world. Still, Americans did understand that while the modern city promised unrivaled prosperity and a wide choice of amusements, these things were not enjoyed by everyone. Whistler and John Singer Sargent were among the many artists to choose beggars as subjects in this period. Sargent's imploring sketch of an exotically-costumed street urchin stands out as one of the most memorable images of this type (fig. 11).

William Glackens's satirical assessment of nightlife in the big city (fig. 12) also bears relating to this subject. Glackens was part of a group of Philadelphia-trained artists who came to the fore of artistic debates at the dawn of the twentieth century.[11] Many of these young men, Glackens included, got their start working as illustrators for local newspapers in the early 1890s. Within a decade, however, all of them had left the newspapers behind and committed themselves to careers as painters in the French Realist mode. The gritty side of urban life was their primary focus. Sometimes derided as an "Ashcan School," because they celebrated the unglamorous details of the city, these artists, Glackens, Henri, Shinn, Luks, George Bellows, and John Sloan among them (fig. 13), opened up these aspects of modern life to artistic representation. This is just to say that, by the end of the period under consideration here, the city might be portrayed as a dynamic, elemental force. Equally likely, it might be shown as mysterious, alienating terrain by a young disciple of the Ashcan School, such as Edward Hopper (fig. 14). Modern urban spaces had indeed become hard places to represent.

Traditional landscape views have a long, distinguished history in American art, but these too present special problems for the period under investigation here. Ever since the first decades of the nineteenth century, American artists had been painting their nation's landscape with a strong sense of pride and the determination to wrest meaning from its topographical features. The Hudson River School, the origins of which are typically traced back to Thomas Cole's pioneering interests in painting that particular geographical area in the mid-1820s, is frequently interpreted as having conferred upon American artists' a privileged legacy as landscapists. That inheritance stretches down to the 1870s, and beyond, in the form of radiant works by Martin Johnson Heade and Thomas Moran (fig. 15). To be sure, these artists shared certain thematic concerns with their European counterparts, but the techniques they applied to them tended to be quite different.[12] Their meticulously painted canvases celebrate America's natural bounty and expansive vistas as pure, even divine phenomena.

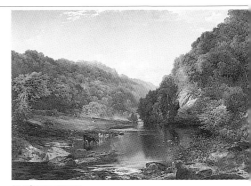

15. **Thomas Moran**,
Autumn on the Wissahickon, 1864

Beginning around the 1870s, however, a competing view of the countryside emerges, one clearly informed by contemporary European approaches to landscape. Artists such as John La Farge and George Inness (fig. 16) exploited this change in numerous rural images from this period. There is something deliberately Arcadian in their views, yet simultaneously something quite modern. And there were good reasons for this particular blending of concerns. These artists sought to marry the traditional and the new. La Farge, for example, was the son of French émigrés to the United States, and he traveled back to France several times between the 1850s and the 1870s. We also know that he was exposed to contemporary French art thought through his American teacher, William Morris Hunt. Hunt was a key advocate of the Barbizon school at home in Boston. Like many artists of this time, La Farge succeeded in exhibiting his landscapes at the Paris Salon, including a view that is closely related to the painting included in *The City and the Country*.[13] La Farge takes an unremarkable rock-strewn landscape around his Rhode Island residence, and treats it in paradisiacal terms. In the more summary brushwork and restricted palette of Inness's painting, one sees evidence of his own appreciation for the Barbizon painters. Whereas the Hudson River School artists favored both theatrical effects and an operatic scale, paintings from this later period typically feature smaller, more intimate views of the terrain, accomplished in a new, wistful technique (fig. 17).

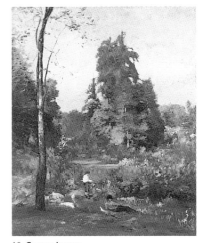

16. **George Inness**,
Summer, Montclair, 1877

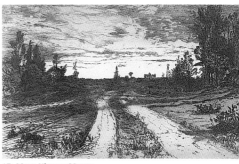

17. **Mary Nimmo Moran**,
Twilight Easthampton, 1880

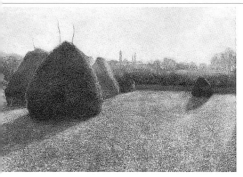

18. **John Leslie Breck**,
Morning Sun and Fog, 1892

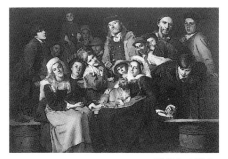

19. **Robert Wylie**,
The Breton Audience, c. 1870

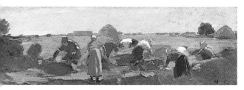

20. **Winslow Homer**,
The Gleaners, 1867

Among the looming influences upon American artists of this period, the importance of Claude Monet and his fellow "Impressionists" cannot be overestimated. Indeed, when Monet decided to settle in Giverny in 1883, his presence soon attracted a number of young Americans to the area. Willard Leroy Metcalf was among the first to arrive at the tiny Norman village around 1885. He was followed shortly by Theodore Robinson, Theodore Butler and John Leslie Breck.[14] Soon, a virtual "invasion" of Americans took place. These artists ultimately formed a vital colony of expatriates at the Normandy border that lasted some thirty years.[15] Painters like Breck (fig. 18) did not simply live in the village, they imitated Monet's technique and took on his favorite subjects. These artists also shared with Monet an intense interest in seasonal effects, something that appears commonly in both the works and their titles.

For all of their emulation and admiration, of course, the Americans only possessed an imperfect understanding of the rural subjects they encountered abroad. Their impression of Normandy was shot through with nostalgia and, at best, a romantic appreciation of peasant life. It was an experience once removed from firsthand cultural understanding — another kind of post-memory. The images they produced are quite fascinating for this reason. Americans represented the French countryside precisely at the moment when this segment of the national life was disappearing from view. Seen by a group that by and large did not fully understand the imperiled nature of their subject, these images may not always avoid sentimentality but they do tend to interpret the scenes somewhat differently than contemporary French artists might. Indeed, it was the purely exotic aura surrounding the peasantry, especially those in Brittany, that ultimately drew many artists into the countryside at this time (fig. 19). These views of country dwellers may be understood in terms of a deliberate search for cultural difference, a difference increasingly difficult to locate in pure form.

During his trip to France in 1866-67, Winslow Homer concentrated his painting efforts on images of peasants toiling in the landscape (fig. 20). The works he produced outside of Paris display an understanding, perhaps more than just intuitive, of the predominant concerns of the Realists. Like Jean-François Millet, Homer devoted himself to depicting the nature of field laborers' existence. Later, like Gustave Courbet, he reveled in desperate scenes of the hunt. On his return to the United States, Homer painted youthful counterparts to the hardworking, hardsporting individuals he had encountered during his sojourn in

Cernay-la-ville. Comparable to Mark Twain's fiction, this impressive body of work is widely regarded as a definitive statement of American rural ideals. Indeed, Homer's reputation as one of the country's greatest artists is closely tethered to his portrayal of just these subjects. In the prints, watercolors, and oils that he produced throughout the 1870s and 1880s, Homer explored the fabled innocence of rural life in America and championed its simple vigor.[16] It is significant that these themes took him far from his native Boston. Country scenes were popular subjects for many nineteenth-century genre painters. John George Brown, for example, has given us comparable images of children taking uncomplicated pleasure from the harvest (fig. 21).

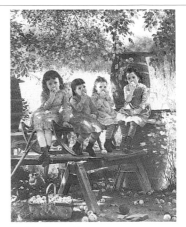

21. **John George Brown**, *The Cider Mill*, 1880

Increasingly, the landscape came to be seen as an opportunity to investigate nature in purely perceptual terms, not as a stage for charming narratives. This was, after all, one of the most profound legacies of Impressionist experiments. Members of the best known group of American Impressionists, The Ten American Painters, applied their French lessons to home contexts in the last decades of the nineteenth century. Attention to light, color and atmosphere pervades the canvases of Edmund C. Tarbell, Willard Leroy Metcalf, William Merritt Chase, and John Henry Twachtman (fig. 22), where the play of sun across trees, hillsides, waterways, and bodies forms a subject in its own right. In the delicate hues and soothing atmosphere of these paintings, one detects a more "therapeutic" approach to viewing the landscape. More didactic concerns of earlier nineteenth-century landscape painting were being left behind.

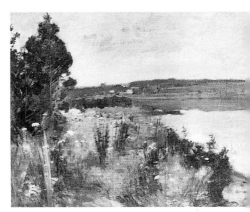

22. **John Henry Twachtman**, *The River*, c. 1884

For twentieth-century artists, the sun-streaked countryside became more and more a respite from the experiences of "cliff dwelling" and darkened valleys created by big-city skyscrapers. Plains and mountains, streams and seashores held strong appeal as destinations for artists long after the Impressionists' era. A new aesthetic attitude toward the common environment was rising throughout this period and "nature" was being appreciated by more than just a few intrepid artists.[17] Indeed, increased leisure time meant that many Americans explored nature as a purely recreational activity and this resulted, perhaps, in a more animated approach to representing nature as well. In 1880, when the famed genre painter Eastman Johnson painted his great image of cranberry pickers along the New England shore (*The Cranberry Harvest,* Timken Museum of Art, San Diego— not in the exhibition) he provided viewers with a scene of communal gathering rich in pictorial incident.[18] When Rockwell Kent painted a similar subject approximately

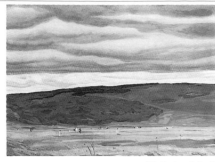

23. **Rockwell Kent**,
Cranberrying, Monhegan, c. 1907

a quarter-century later (fig. 23), he dispatched the subject's narrative dimensions. In the place of story telling, Kent celebrated the stark island landscape of Maine and set his image of scarcely-nuanced figures against tight chromatic bands of energetically brushed color.

Painters commonly associated with urban life may have started venturing outside of city limits in search of psychic relief. Once there, however, they applied their unrestrained Realist techniques to places that had long been viewed as interesting subjects for artists. The result was an uncompromisingly new assessment of these settings. George Bellows's large canvas *The Palisades* (Fig. 24) records this much with its slashing distribution of pigment and plunging, dynamic composition. Some modernists were still more brazen in their quest for untrammeled terrain, however. After witnessing a variety of shocking, new representations at the Armory Show, in 1913, young artists deliberately sought out new destinations in which they hoped to think through the problems of modern art practice. Many ended up in art colonies far from the principal metropolitan art centers. Western states like New Mexico and California proved extremely attractive to these artists. For most of these men and women, their adventures in the West provided an opportunity to explore vast, unpopulated landscapes.[19] When Marsden Hartley and Gustave Baumann first viewed the high desert and forest of the Southwest, they assessed the uncluttered spaces and brilliant sunshine as aids to their own abstracting vision. The country would never look quite the same again.

The root meaning of the word "landscape" is simple: a collection of similar spaces.[20] The ways that landscape imagery in the United States changed between 1870 and 1920 may not be so simply, or tidily, defined. In a period of tremendous social and demographic change, American artists struggled to come to terms with a widening rift between urban and rural ideals. Add to that a strong infusion of French vanguard concerns, and we can begin to appreciate the various currents that run throughout landscape representations of this time. In viewing works from this fifty-year period, we witness how the basic approach to seeing and being in these two very different contexts underwent abrupt, sometimes even spasmodic change. This was indeed a crucial interval in American art history. We should not underestimate the important solutions that artists came

up with as they endeavored to answer the key questions of "what to" and "how to" represent the world around them. Caught between two kinds of places —the hard circumstances of the city and the rocky conditions of the countryside — the works gathered together for purposes of this exhibition succeed as poignant, complex images. Their enduring interest for us suggests that we have not yet answered all the questions that they necessarily raise. ∎

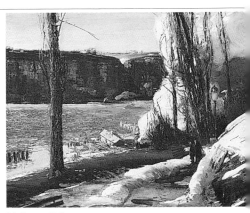

24. **George Bellows**,
The Palisades, 1909

NOTES

1 For specific details of this demographic change, see A. Lees, *Cities Perceived: Urban Society in European and American Thought, 1820-1940* (New York: Columbia University Press, 1985). The impact of this transformation upon cultural matters is also described in R. Williams, *The Country and the City* (New York: Oxford University Press, 1973).

2 See H. Barbara Weinberg, "Nineteenth-Century American Painters at the École des Beaux-Arts," *The American Art Journal* 13 (Autumn 1981): 66-84; D. R. Cartwright, *The Studied Figure: Tradition and Innovation in American Art Academies* (San Francisco: The Fine Arts Museums of San Francisco, 1987).

3 On the phenomenon of American artists' success at French public exhibitions in this period, see L. Fink, *American Art at the Nineteenth-Century Paris Salons* (Washington, D.C.: Smithsonian Institution Press, 1990).

4 See "Selected Bibliography" section at the end of this catalogue for a listing of relevant titles.

5 The notion of "post-memory" employed here is usefully described in M. Hirsch, *Family Forms: Photography, Narrative, and Post-Memory* (Cambridge: Harvard University Press, 1997).

6 M. Brown, in *American Painting from the Armory Show to the Depression* (Princeton: Princeton University Press, 1955): 118.

7 P. Bourget, *Outre-Mer: Notes sur l'Amérique* 2 vols. (Paris: A. Lemerre, 1894); H. James, *The American Scene* (New York: Harper & Brothers, 1907).

8 See, for example, A. Blaugrund, et al., *Paris 1889: American Artists at the Universal Exposition* (Philadelphia: Pennsylvania Academy of the Fine Arts, 1989).

9 S. Hartmann, "Studio Talk," *International Studio* 29 (September 1906): 267.

10 For an account of this controversy, see M. Smart, *A Flight with Fame: The Life and Art of Frederick MacMonnies* (Madison, CT: Sound View Press, 1996): 167-175.

11 The personal and professional connections between these artists are discussed in W. I. Homer, *Robert Henri and His Circle* (Ithaca: Cornell University Press, 1969): esp. pp. 75-82.

12 Martin Johnson Heade's complex relationship to Barbizon and Impressionist concerns is illuminating in this regard. See T.E. Stebbins, Jr., *The Life and Works of Martin Johnson Heade* (New Haven: Yale University Press, 1975), esp. pp. 54-55.

[13] La Farge exhibited a painting entitled *The Last Valley,* identified as a Newport, R.I. view, at the 1874 Salon. For information on the artist's early career, see H. Adams, et al., *John La Farge* (New York: Abbeville Press, 1987).

[14] See C. Joyes, *Claude Monet: Life at Giverny* (London: Thames and Hudson, 1985): 53-60. See also P. H. Tucker, *Claude Monet: Life and Art* (New Haven: Yale University Press, 1995).

[15] On the Americans' presence in Giverny, see W. Gerdts, *Monet's Giverny: An Impressionist Colony* (New York: Abbeville Press, 1993) and D. Sellin, *Americans in Brittany and Normandy: 1860-1910* (Phoenix: Phoenix Art Museum, 1982).

[16] For a summary of Homer's concerns in this period, see J. Wierich, "Beyond Innocence: Images of Boyhood from Winslow Homer's First Gloucester Period," in *Winslow Homer in Gloucester* (Chicago: Terra Museum of American Art, 1990): 30-45.

[17] See M. Schapiro, *Impressionism: Reflections and Perceptions* (New York: George Braziller, 1997): 87-88.

[18] The Timken's painting of this subject has been thoroughly studied. See M. Simpson, et al., *Eastman Johnson, The Cranberry Harvest, Island of Nantucket* (San Diego: Timken Museum of Art, 1990).

[19] Chase, Hassam and Henri all visited California around 1914, for example. See D. R. Cartwright, "Modern Conditions: A Chronology of Institutions, Events, and Individuals," in P. J. Karlstrom, ed. *On the Edge of America: California Modernist Art, 1900-1950* (Berkeley: University of California Press, 1996): 272-87. On artists' growing interest in New Mexico, see S. R. Udall, *Modernist Painting in New Mexico* (Albuquerque: University of New Mexico Press, 1984).

[20] See J. B. Jackson, "The Word Itself," in H. L. Horowitz, ed., *Landscape in Sight: Looking at America* (New Haven: Yale University Press, 1997): 299-306.

Checklist to the Exhibition

Notes: *The City and the Country: American Perspectives, 1870-1920* is comprised of 112 works of art in a variety of different media. All works are lent by the Terra Foundation for the Arts / Daniel J. Terra Collections. Height precedes width in dimensions given below. Because of preservation concerns, works of art on paper are on view only from 1 April-15 July 1999.

John Taylor Arms (1887-1953)
The Gates of the City
1922
Etching and aquatint, 8½ x 7¹⁵/₁₆ in.
1996.3

West 42nd Street, Night
1922
Etching and aquatint, 10⁵/₈ x 6³/₄ in.
1996.2

Gustave Baumann (1881-1971)
Aspen Red River
1918
Color woodcut, 9¼ x 11½ in.
1996.12

Bound for Taos
1930
Color woodcut, 9¼ x 11 1/8 in.
1996.13

James Carroll Beckwith (1852-1917)
French Spring
c. 1885
Oil on panel, 10³/₈ x 13³/₄ in.
1987.14

George Bellows (1882-1925)
The Palisades
1909
Oil on canvas, 30 x 39¹/₈ in.
22.1983

Isabelle Bishop (1902-1988)
Noon Hour
1935
Etching, 6³/₄ x 4⁵/₁₆ in.
1996.84

Frank Myers Boggs (1855-1926)
Street Scene in Paris
1878
Oil on canvas, 37½ x 59 in.
12.1994

John Leslie Breck (1860-1899)
Morning Fog and Sun
1892
Oil on canvas, 32 x 46³/₁₆ in.
1.1991

Studies of an Autumn Day
1891
Oil on canvas, 12⁷/₈ x 16¹/₄ in
1989.4.1-1989.4.12 (twelve works)

John George Brown (1831-1913)
The Cider Mill
1880
Oil on canvas, 30 x 24 in.
1992.19

Dennis Miller Bunker (1861-1890)
Brittany Town Morning, Larmor
1884
Oil on canvas, 14 x 22 in.
1991.1

Lacroix-St-Ouen, Oise, 1883
Oil on canvas, 37⁵/₈ x 50¹/₈ in.
1987.11

Theodore Earl Butler (1861-1936)
Place de Rome at Night
1905
Oil on canvas, 23½ x 28³/₄ in.
1994.16

Mary Cassatt (1844-1926)
Afternoon Tea Party
1890-91
Drypoint and aquatint with touches of gold hand-coloring, 13·¹/₁₆ x 10⁵/₈ in.
1994.13

In the Omnibus
1890-91
Drypoint and aquatint
14⁷/₁₆ x 10⁹/₁₆ in.
29.1985

William Merritt Chase (1849-1916)
The Olive Grove
c. 1910
Oil on composition board
23½ x 33½ in. 1992.25

Glenn O. Coleman (1887-1932)
Bonfire
1928
Lithograph, 12¹/₈ x 16¹⁵/₁₆ in.
1996.67

Howard Cook (1901-1980)
Skyscraper
1928
Wood engraving, 18 x 8⁵/₈ in.
1995.28

**Charles Courtney Curran
(1861-1942)**

In the Luxembourg Garden
1889
Oil on panel, 9³/16 x 12¹/4 in.
1992.167

Paris at Night
1889
Oil on panel, 9¹/16 x 12¹/4 in.
1989.12

Charles Harold Davis (1856-1933)
Champ de blé
1883
Oil on canvas, 10¹/2 x 13⁷/8 in.
1992.12

Stuart Davis (1894-1964)
Rue des rats
1929
Lithograph, 10 x 15³/16 in.
1996.68

Charles Demuth (1883-1935)
Rue du singe qui pêche
1921
Tempera on board, 20⁹/16 x 16¹/8 in.
36.1985

Welcome to Our City
1921
Oil on canvas, 25¹/8 x 20¹/8 in.
1993.3

Louis Paul Dessar (1867-1952)
Peasant Woman and Haystacks, Giverny
1892
Oil on canvas, 18¹/2 x 13 in.
1993.9

Arthur Wesley Dow (1857-1922)
Moonrise
c. 1898-1905
Color woodcut, 4¹/4 x 7 in.
1996.4

The Purple Sky (The Long Road, Spring)
1916
Color woodcut, 4¹/4 x 7¹/16 in.
1995.32

**Charles Henry Fromuth
(1858-1937)**
Morning Haze, Winter, Concarneau
1892
Oil on canvas, 18¹/4 x 24¹/4 in.
1988.6

**William James Glackens
(1870-1938)**
Bal Bullier
c. 1895
Oil on canvas, 18¹/4 x 24¹/2 in.
1.1995

A Headache in Every Glass
1903-04
Charcoal and watercolor, 13¹/4 x 19¹/2 in.
1992.170

Bernhard Gutmann (1863-1936)
Breton Lacemakers
1912
Oil on canvas, 32 x 39¹/2 in.
1988.18

Marsden Hartley (1877-1943)
New Mexico Landscape
1918
Pastel, 17¹/4 x 27⁷/8 in.
1994.19

**Frederick Childe Hassam
(1859-1935)**
Commonwealth Avenue, Boston
c. 1892
Oil on canvas, 22¹/4 x 30¹/4 in.
1992.39

French Peasant Girl
c. 1883
Oil on canvas, 21⁵/8 x 13⁷/8 in.
1989.21

Horse Drawn Cabs at Evening, New York
c. 1890
Watercolor, 14 x 17³/4 in.
2.1996

Une averse, rue Bonaparte
1887
Oil on canvas, 40³/8 x 77⁷/16 in.
1993.20

*Washington's Birthday—Fifth Avenue
& 23ʳᵈ Street*
1916
Etching and drypoint, 12³/4 x 7 in.
1995.1

**Martin Johnson Heade
(1819-1904)**
*Newburyport Marshes:
Approaching Storm*
1865-1870
Oil on canvas, 15¹/4 x 30³/8 in.
1.1984

Robert Henri (1865-1929)
Paris café, Montparnasse
1898
Oil on canvas, 18³/8 x 24³/8 in.
1992.171

Street Corner in Paris
1896
Oil on panel, 3⁷/8 x 6¹/8 in.
13.1994

Winslow Homer (1836-1910)
Apple Picking (Two Girls in Sunbonnets)
1878
Watercolor and gouache, 7 x 8³/8 in.
1992.7

The Gleaners
1867
Oil on panel, 6 x 18 in.
2.1995

Haymakers
1867
Oil on canvas, 13¹/8 x 18 ¹/4 in.
1989.9

The Whittling Boy
1873
Oil on canvas, 15 ³/4 x 22¹¹/16 in.
1994.12

Edward Hopper (1882-1967)

Night in the Park
1921
Etching, $6^{13/16}$ x $8^{1/4}$ in.
1995.39

Night Shadows
1921
Etching, $6^{7/8}$ x $8^{1/4}$ in.
1995.7

George Inness (1825-1894)

Summer, Montclair
1877
Oil on canvas, $41^{13/16}$ x $33\ 3/4$ in.
44.1980

Rockwell Kent (1882-1971)

Cranberrying, Monhegan
c. 1907
Oil on canvas, $28^{1/16}$ x $38^{1/4}$ in.
C1983.4

John La Farge (1835-1910)

Paradise Valley
c. 1865
Oil on canvas, $32^{5/8}$ x 42 in.
1996.92

Ernest Lawson (1873-1939)

Brooklyn Bridge
1917-1920
Oil on canvas, $20^{3/8}$ x 24 in.
1992.43

Spring Thaw
c. 1910
Oil on canvas, $25^{1/4}$ x $30^{1/8}$ in.
21.1980

Martin Lewis (1881-1962)

Glow of the City
1929
Etching, $11^{7/16}$ x $14^{5/16}$ in.
1995.42

Stoops in Snow
1930
Drypoint, 9 7/8 x 15 in.
1996.49

Louis Lozowick (1892-1973)

Minneapolis
1925
Lithograph, $11^{5/8}$ x $8^{7/8}$ in.
1995.9

New York
1925
Lithograph, $11^{7/16}$ x 9 in.
1995.10

George Luks (1866-1933)

*Knitting for the Soldiers:
High Bridge Park*
c. 1918
Oil on canvas, $30^{3/16}$ x $36^{1/8}$ in.
2.1990

Fernand Lungren (1857-1932)

Paris Street Scene
1882
Watercolor, $12^{5/8}$ x $21^{1/2}$ in.
1989.25

Frederick William MacMonnies (1863-1937)

Bacchante and Infant Faun
1894
Bronze, $34\ 3/4$ x $11^{1/2}$ x $11^{1/2}$ in.
1988.20

John Marin (1870-1953)

Brooklyn Bridge, on the Bridge
1930
Watercolor, $21^{3/4}$ x $26^{3/4}$ in.
11.1981

Woolworth Building, n° 2
1913
Etching and drypoint, $12^{7/8}$ x $10^{7/16}$
1995.16

Willard Leroy Metcalf (1858-1925)

Au café
1888
Oil on panel, $13^{11/16}$ x $6^{1/16}$ in.
1992.10

The River Epte, Giverny
1887
Oil on canvas, $12^{1/4}$ x $15^{7/8}$ in.
1989.6

Richard Emil Miller (1875-1943)

Café de nuit (L'heure de l'apéritif)
c. 1906
Oil on canvas, $48^{1/2}$ x $67^{3/8}$
39.1985

Mary Nimmo Moran (1842-1899)

Twilight Easthampton
1880
Etching, $7^{3/4}$ x $11^{3/4}$ in.
1996.82

Thomas Moran (1837-1926)

Autumn on the Wissahickon
1864
Oil on canvas, $30^{1/4}$ x $45^{1/4}$ in.
6.1994

James Wilson Morrice (1865-1924)

Scene in Brittany
1896-1898
Oil on canvas mounted on board, 9 x 13 in.
1993.19

Elizabeth Nourse (1860-1938)

Rue d'Assas, Paris
1929
Watercolor, chalk and pastel,
$20^{7/8}$ x $13^{1/2}$ in.
10.1990

Pauline Palmer (1867-1938)
The Orchard
n.d.
Oil on paper, 14 1/2 x 11 1/2 in.
1.1996

Charles Sprague Pearce (1851-1914)
Evening (Auvers-sur-Oise)
c. 1885
Oil on canvas, 41 x 69 1/2 in.
1994.15

Joseph Pennell (1857-1926)
Sketch of a European Street Scene
1904
Ink on board, 8 1/4 x 5 3/4 in.
C1983.7

Jane C. Peterson (1876-1965)
Marché aux fleurs
1908
Oil on canvas, 17 1/8 x 23 1/8 in.
1994.17

Maurice Brazil Prendergast (1858-1924)
Franklin Park, Boston
1895-97
Watercolor and graphite, 17 1/2 x 13 1/2 in.
31.1985

Lady on the Boulevard
1892-94
Oil on panel, 13 5/8 x 7 1/8 in.
1992.64

The Luxembourg Garden, Paris
1892-94
Oil on canvas, 12 7/8 x 9 5/8 in.
1992.68

Edward Willis Redfield (1869-1965)
France
1898-1899
Oil on canvas, 31 1/4 x 40 3/16 in.
1992.126

Louis Ritter (1854-1892)
Willows and Stream, Giverny
1887
Oil on canvas, 25 7/8 x 21 3/8 in.
1992.129

Theodore Robinson (1852-1896)
Blossoms at Giverny
1891-1893
Oil on canvas, 21 5/8 x 20 1/8 in.
1992.130

From the Hill, Giverny
c. 1889
Oil on canvas, 15 7/8 x 25 7/8 in.
1987.6

Winter Landscape
1889
Oil on canvas, 18 1/4 x 22 in.
34. 1980

Guy Rose (1867-1925)
Giverny Hillside
1890-95
Oil on panel, 12 7/16 x 16 1/8 in.
1992.2

John Singer Sargent (1856-1925)
A Parisian Beggar Girl
c. 1880
Oil on canvas, 25 3/8 x 17 3/16 in.
1994.14

Charles Sheeler (1883-1965)
Delmonico Building
1927
Lithograph, 6 3/4 x 7 1/2 in.
1995.3

Everett Shinn (1876-1953)
Theater Scene
1903
Oil on canvas, 12 3/4 x 15 1/2 in.
22.1985

Edward Emerson Simmons (1852-1931)
Boston Public Garden
1893
Oil on canvas, 18 x 26 in.
34.1984

John Sloan (1871-1951)
Easter Eve, Washington Square
1926
Etching and aquatint, 9 13/16 x 7 13/16 in.
1995.19

Turning out the Light
1905
Etching, 4 5/8 x 6 9/16 in.
1995.21

Henry Ossawa Tanner (1859-1937)
Les Invalides, Paris
1896
Oil on canvas, 13 1/8 x 16 1/8 in.
27.1983

Edmund Charles Tarbell (1862-1938)
In the Orchard
1891
Oil on canvas, 60 3/4 x 65 1/2 in.
1.1992

John Henry Twachtman (1853-1902)
Pasture with Barns
1890-1900
Pastel, 17 5/16 x 22 5/8 in.
1992.135

The River
c. 1884
Oil on canvas, 18 1/4 x 22 1/4 in.
1989.1

Road near Honfleur
1884-85
Oil on paper on canvas, 30 x 21 in.
1989.15

Bessie Potter Vonnoh (1872-1955)

In Arcadia
c. 1926
Bronze, 12 x 28$^{3/8}$ x 6$^{3/4}$ in.
1989.3

Robert Vonnoh (1858-1933)

Jardin de paysanne
1890
Oil on canvas board, 25$^{7/8}$ x 19$^{3/4}$ in.
1987.8

La sieste
1887
Oil on panel, 8$^{1/2}$ x 10$^{9/16}$ in.
1992.139

Martha Walter (1875-1976)

A la crémerie
1910
Oil on canvas board, 12$^{7/8}$ x 16 in.
13.1981

Theodore Wendel (1859-1932)

Flowering Fields, Giverny
c. 1887
Oil on canvas, 12$^{1/2}$ x 21$^{5/8}$ in.
1988.11

**James Abbott McNeill Whistler
(1834-1903)**

The Beach at Marseille
c. 1901
Oil on panel, 8$^{1/16}$ x 13$^{1/16}$ in.
1992.143

Beggars
1879-80
Drypoint, 11$^{15/16}$ x 8$^{5/16}$ in.
1994.8

Flower Shop, Dieppe
c.1885
Watercolor, 9$^{11/16}$ x 5$^{3/4}$ in.
1994.2

Robert Wylie (1839-1877)

The Breton Audience
1870
Oil on canvas, 21$^{1/2}$ x 29$^{1/4}$ in.
1992.166

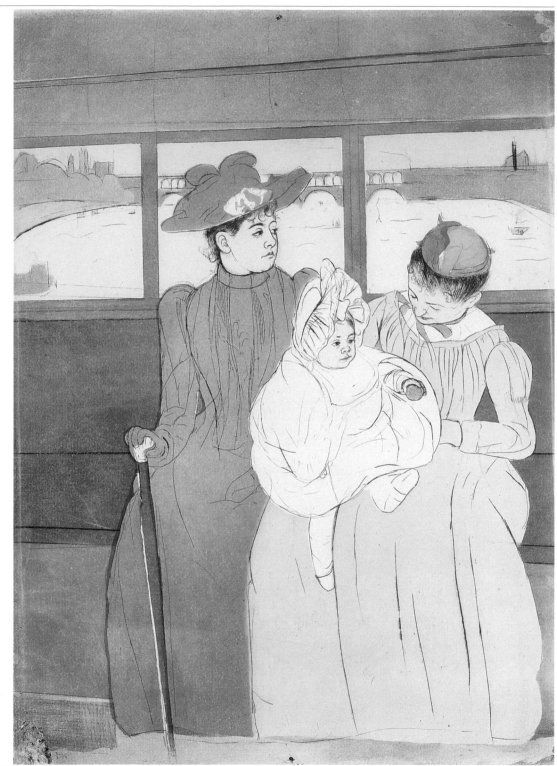

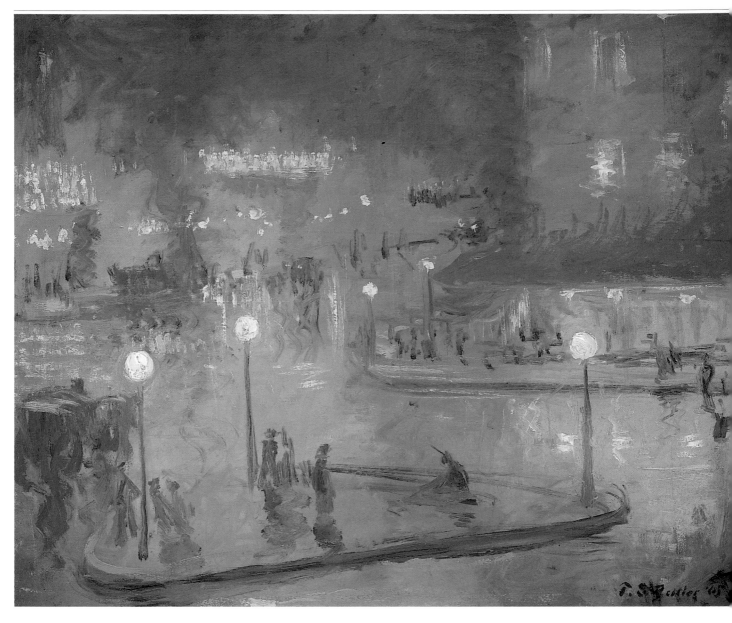

Theodore Butler,
Place de Rome at Night / Place de Rome la nuit,
1905

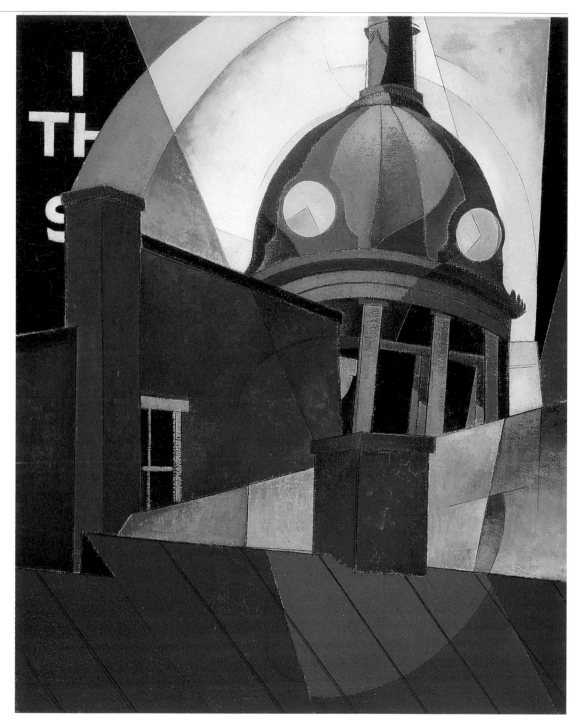

Charles Demuth,
Welcome to Our City /
Bienvenue dans notre ville,
1921

Frederick Childe Hassam,
Horse Drawn Cabs at Evening, New York /
Les fiacres le soir à New York,
c. 1890

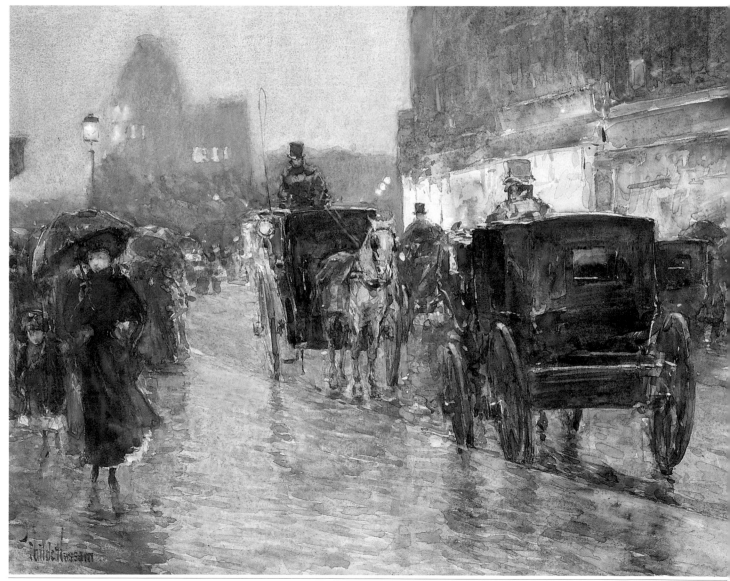

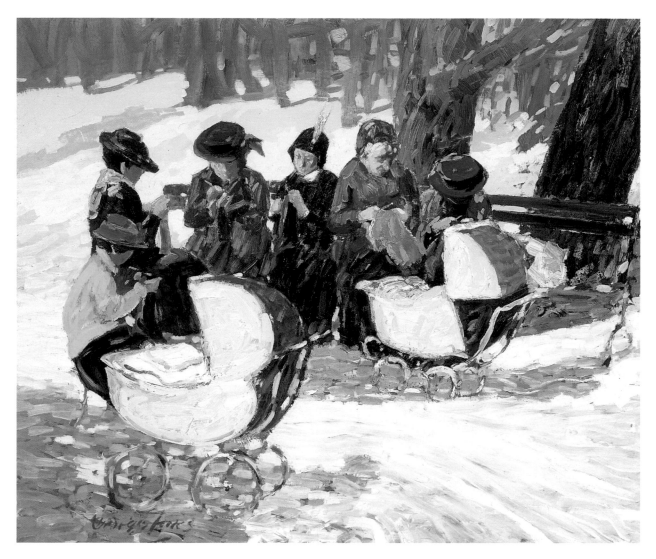

George Luks,
Knitting for the Soldiers : High Bridge Park /
Des tricots pour les soldats : parc de High Bridge,
c. 1918

Fernand Lungren, *Paris Street Scene /*
Scène de rue à Paris,
1882

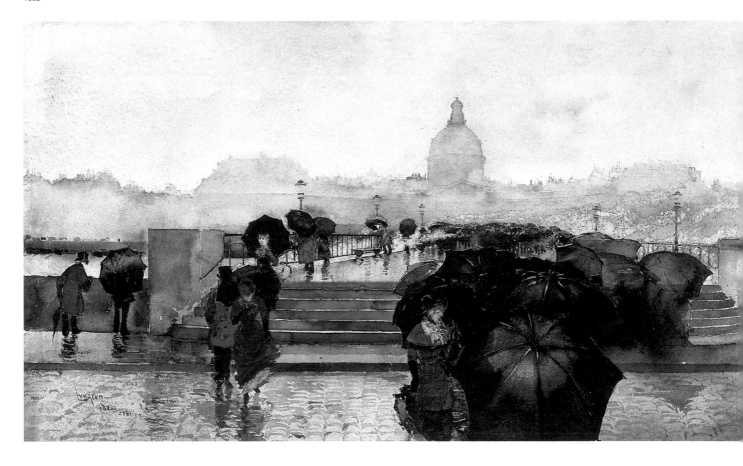

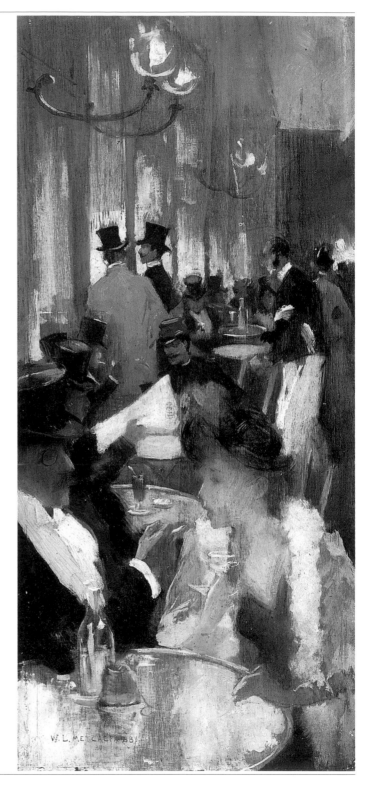

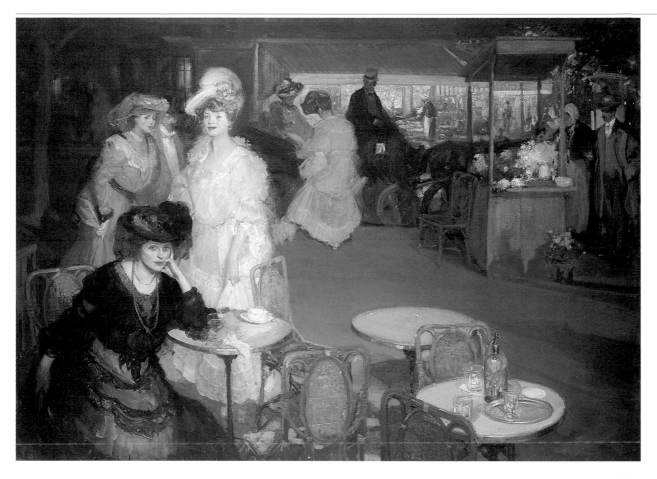

Richard Emil Miller,
Café de nuit (L'heure de l'apéritif),
c. 1906

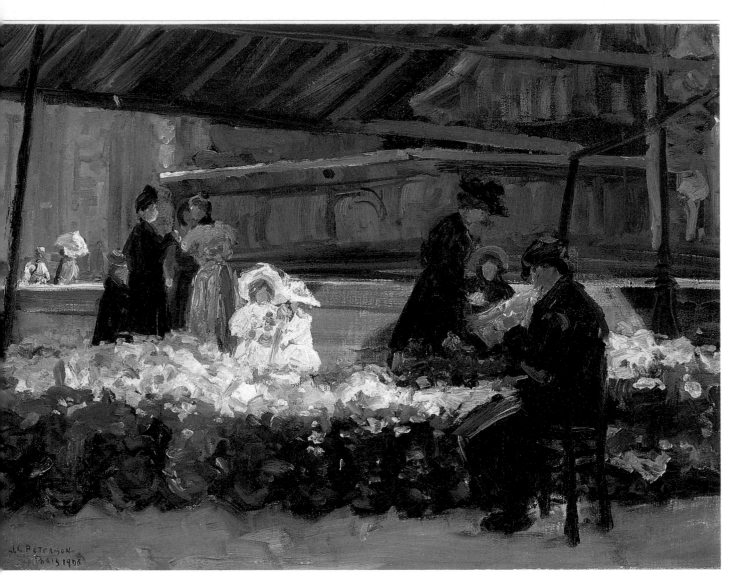

Jane C. Peterson,
Marché aux fleurs,
1908

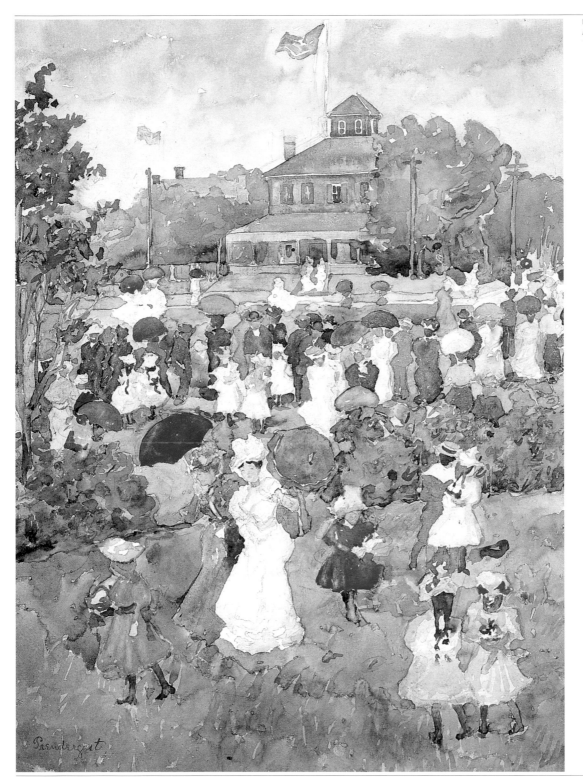

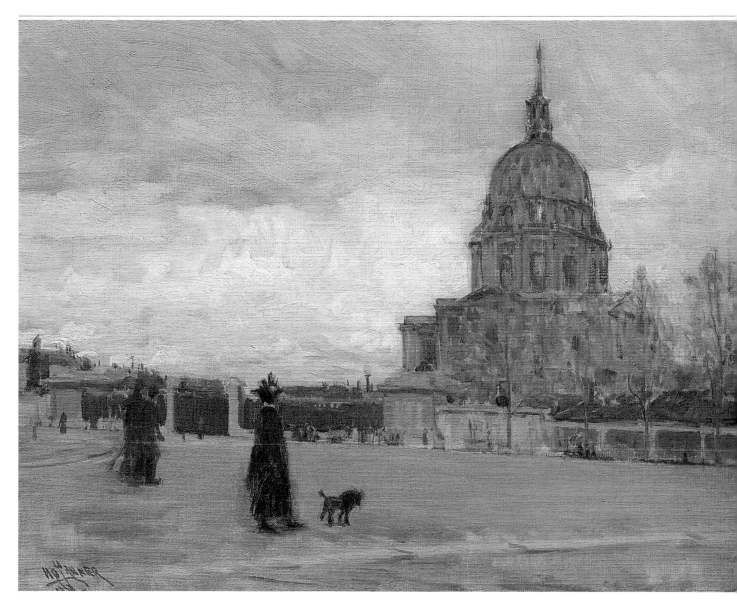

Henry Ossawa Tanner,
Les Invalides, Paris,
1896

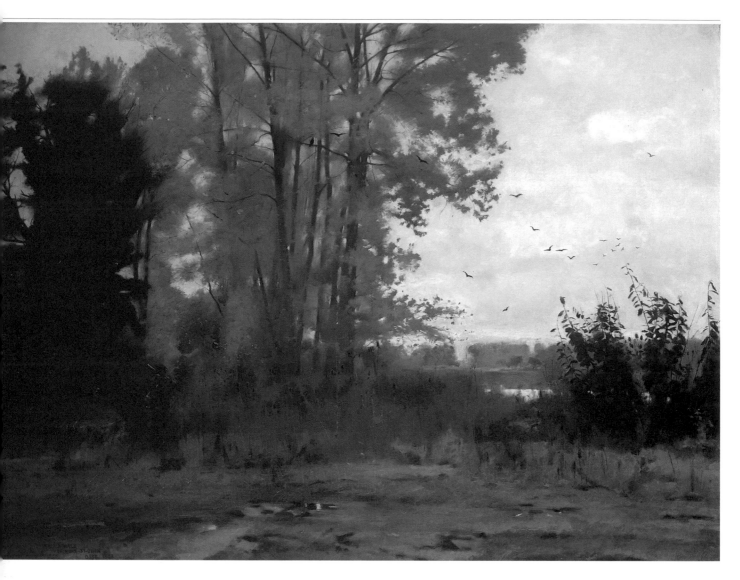

Dennis Miller Bunker,
Lacroix, St-Ouen, Oise,
1883

William Merritt Chase,
The Olive Grove /
L'oliveraie,
c. 1910

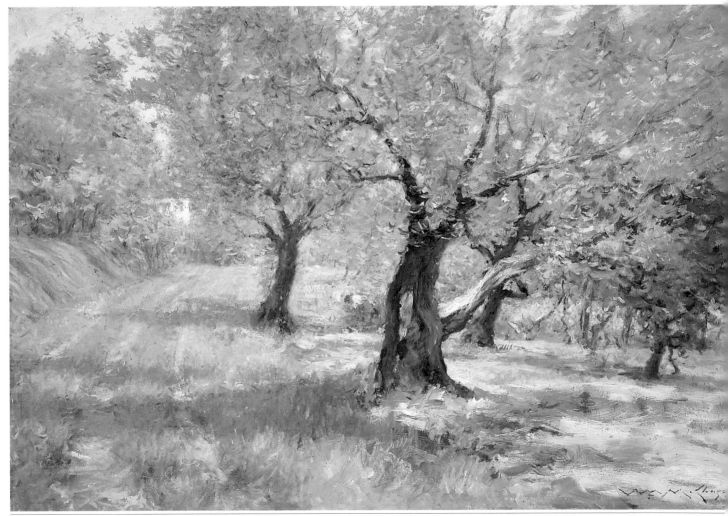

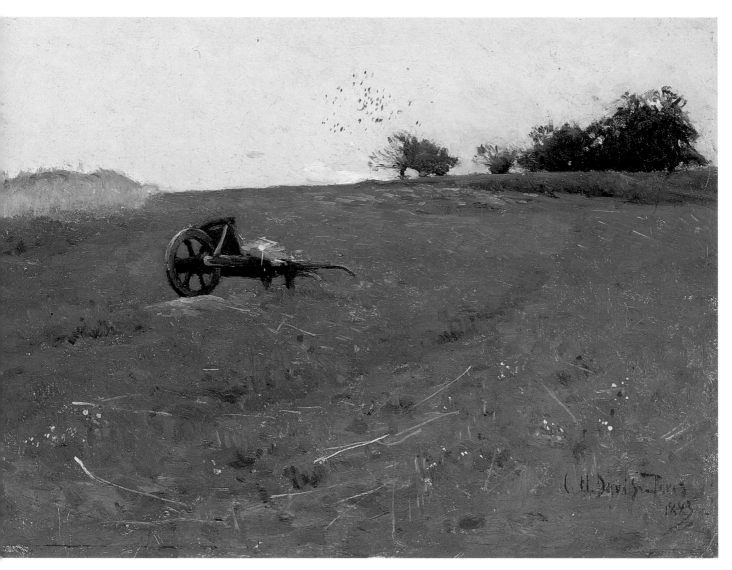

Marsden Hartley,
New Mexico Landscape /
Paysage du Nouveau-Mexique,
1918

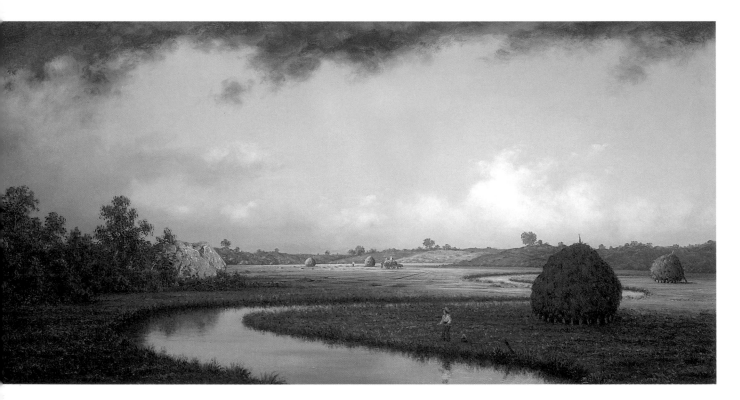

Martin Johnson Heade,
Newburyport Marshes : Approaching Storm /
Les marais de Newburyport : l'approche de l'orage,
1865-70

Winslow Homer,
The Whittling Boy /
Garçon taillant une branche,
1873

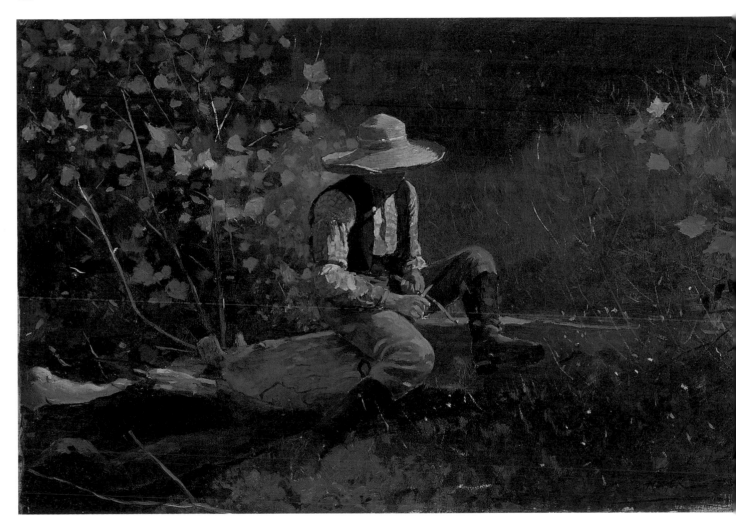

John La Farge,
Paradise Valley,
c. 1865

Charles Sprague Pearce,
Evening (Auvers-sur-Oise) /
Le soir, Auvers-sur-Oise,
c. 1885

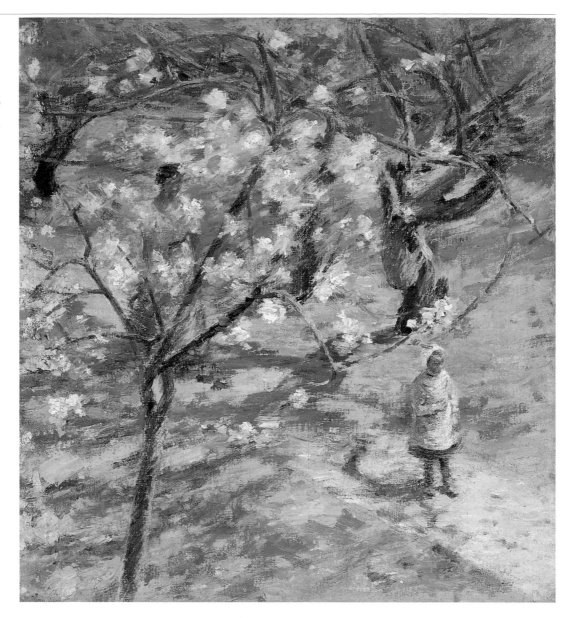

Theodore Robinson,
Blossoms at Giverny /
Arbres en fleurs à Giverny,
1891-93

Guy Rose,
Giverny Hillside /
Colline à Giverny,
1890-95

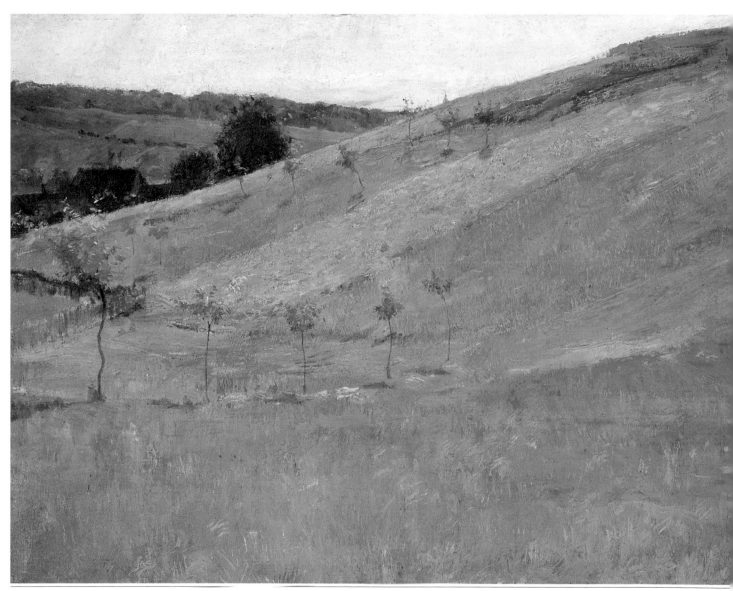

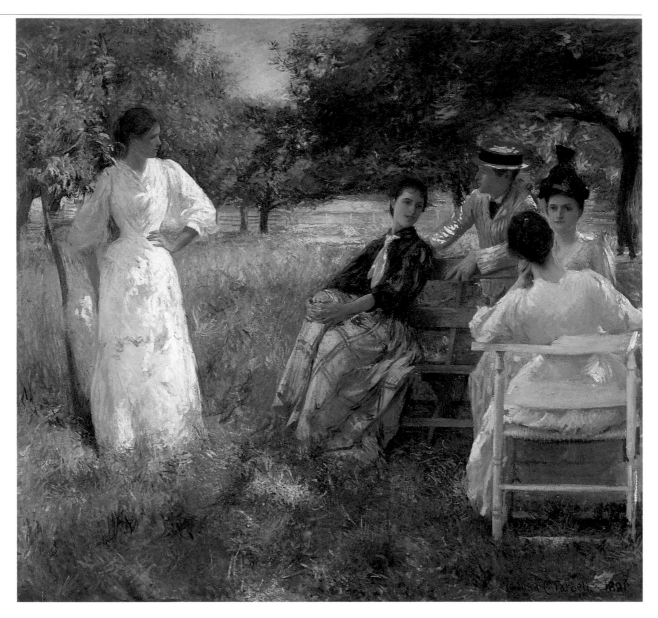

Edmund Charles Tarbell,
In the Orchard /
Au verger,
1891

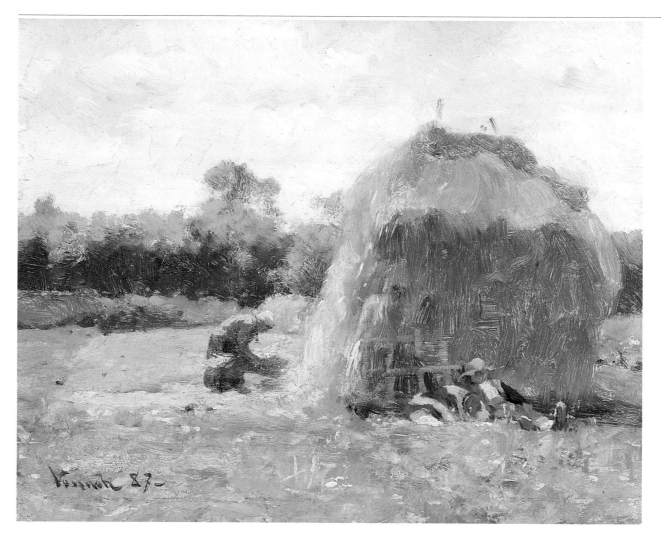

Robert Vonnoh,
La sieste,
1887

Selected Bibliography

Bermingham, Peter. *American Art in the Barbizon Mood.* Washington, D.C.: National Collection of Fine Arts, Smithsonian Institution, 1975.

Broude, Norma, ed. *World Impressionism: The International Movement, 1860-1920.* New York: Harry N. Abrams, 1990.

Burns, Sarah. *Pastoral Inventions—Rural Life in Nineteenth-Century American Art and Culture.* Philadelphia: Temple University Press, 1989.

Clark, T. J. *The Painting of Modern Life: Paris in the Art of Manet and His Followers.* Princeton: Princeton University Press, 1984.

Gerdts, William H. *American Impressionism.* New York: Artabras Publishers, 1984.

_____. *Lasting Impressions: American Painters in France, 1865-1915.* Chicago: Terra Foundation for the Arts, 1992.

Herbert, Robert. *Impressionism: Art, Leisure, & Parisian Society.* New Haven: Yale University Press, 1988.

Hiesinger, Ulrich W. *Impressionism in America: The Ten American Painters.* Munich: Prestel, 1991.

Jacobs, Michael. *The Good and Simple Life: Art Colonies in Europe and America.* London: Oxford University Press, 1985.

Mitchell, W.J.T., *ed. Landscape and Power.* Chicago: University of Chicago Press, 1994.

Nochlin, Linda. *Realism.* New York: Penguin Books, 1971.

Perlman, Bennard B. *Painters of the Ashcan School: The Immortal Eight.* New York: Dover Publications, Inc., 1988.

Pisano, Ronald G. *Idle Hours: Americans at Leisure, 1865-1914.* Boston: A New York Graphic Society Book, 1988.

Pyne, Kathleen A. *Art and the Higher Life: Painting and Evolutionary Thought in Late Nineteenth Century America.* Austin: University of Texas Press, 1996.

Quick, Michael. *American Expatriate Painters of the Late Nineteenth Century.* Dayton: Dayton Art Institute, 1976.

Schama, Simon. *Landscape and Memory.* New York: Alfred A. Knopf, 1995.

Schleier, Merrill. *The Image of the Skyscraper in American Art.* Ann Arbor: UMI Research Press, 1986.

Weinberg, H. Barbara, et al. *American Impressionism and Realism: The Painting of Modern Life, 1885-1915.* New York: Metropolitan Museum of Art, 1994.

_____. *The Lure of Paris: Nineteenth Century American Painters and Their French Teachers.* New York: Abbeville Press, 1991.

Zurier, Rebecca, et al. *Metropolitan Lives: The Ashcan School and Their New York.* New York: W.W. Norton, Ltd., 1995.

Photo: J-F Lefèvre

Musée d'Art Américain Giverny

99, rue Claude Monet
27620 Giverny - France
Tel. 33 (0) 2 32 51 94 65
Fax 33 (0) 2 32 51 94 67

Terra Museum of American Art

664 North Michigan Avenue
Chicago, Illinois 60611 – USA
Tel: (312) 664-3939
Fax: (312) 664-2052